HOKUSAI
100 WRITING & CRAFTING PAPERS
北斎100枚レターブック

江戸時代中期から後期にかけて活躍した浮世絵師・葛飾北斎。浮世絵師としては遅咲きの40代後半から頭角を現し、90歳までの画家人生で3万点以上の作品を描きました。北斎の斬新な作品は19世紀の欧米を席捲したジャポニズムにも影響を与え、日本を代表する画家の一人として海外でも高く評価されています。

　生涯で93回の引越しをし、画号も20数回変更するなど、多くの奇行が伝えられる北斎ですが、その人生に関する資料は少なく、謎の多い人物です。江戸末期に女性の浮世絵師として活躍した葛飾応為は、北斎の娘として知られています。

　宝暦10（1760）年9月、北斎は本所割下水（現在の墨田区亀沢付近）で生まれました。幼名は時太郎、後に鉄蔵と改めました。父親は川村氏としかわからず、4歳で幕府の御用鏡師・中島伊勢の養子となります。6歳から好んで絵を描いて過ごし、貸本屋の小僧を経て14歳頃には版木彫り職人に弟子入りしたと後年に北斎自身が述懐していますが、詳細は不明です。

　安永7（1778）年、19歳のときに役者絵の第一人者・勝川春章に入門、浮世絵師として本格的に修業を始めます。翌年には勝川春朗の画号でデビュー。勝川派の絵師として錦絵や黄表紙の挿絵などを描きました。

　寛政6（1794）年、勝川派を離れた北斎は琳派の流れをくむ「俵屋宗理」の名を襲名、豪華な摺物や狂歌本の挿絵、肉筆画などを手がけます。

　寛政10（1798）年には「北斎辰政」を名乗って琳派からも独立。以降、どの流派にも属さない絵師となります。

　文化2（1805）年になって「葛飾北斎」の画号を使用するようになり、この頃から曲亭馬琴や柳亭種彦など、当代一流の戯作者と提携した読本挿絵を精力的に描きました。魅力的なキャラクター設定、力強く緻密な描写、墨の濃淡を使った奥行のある表現、奇抜な構図など、さまざまな創意工夫を凝らし、北斎が挿絵を手がけたからこそ読本が大流行したともいわれています。北斎が挿絵を手がけた読本は200冊ほどあり、その代表作には馬琴と組んだ『新編水滸画伝』『鎮西八郎為朝外伝　椿説弓張月』があります。

　文化7（1810）年から「戴斗」の画号を使用するようになった北斎は、次第に読本挿絵から離れ、興味と制作の対象を絵手本へと移行します。絵手本の代表作が、弟子たちのお手本集として描かれた『北斎漫画』（全15編）で、さまざまな人物、建物、日用品、風景、気象などの森羅万象を描き、総図数は約3,900点とされています。また、高い視点から東海道や江戸湾を一望する鳥瞰図などの錦絵もこの時期に制作しています。

文政3（1820）年から天保4（1833）年までの13年間は「為一」の画号を使用し、『元禄歌仙貝合』（全36図）と『馬尽』（全30図）などの摺物を手がけました。この時期は錦絵の制作も精力的に行っていた時期です。代表作『冨嶽三十六景』を制作したのは、北斎が70代前半の頃です。ほかにも、『諸国瀧廻り』『諸国名橋奇覧』などの風景画や花鳥画、古典や怪談をモチーフにした錦絵の秀作を生み出しました。

　天保5（1834）年、75歳になった北斎は、風景絵本『富嶽百景』初編で最後の画号となる「画狂老人卍」を使用。老いてなお旺盛な制作意欲を持ち、風俗画から和漢の故事や宗教に基づく歴史画、物語画へと題材の変化が見られます。

　嘉永2（1849）年春、病気のため90年の生涯を閉じた北斎。貪欲に独自の画風を追求し、今際の際まで絵筆を握り続け、死の床でも真の絵師となりたいと切望していたと伝えられています。

葛飾北斎（1760～1849年）
渓斎英泉画『戯作者考補遺』木村黙老 著 1935年（国本出版社）
出典：国立国会図書館デジタルコレクション

Katsushika Hokusai (1760–1849)

Ukiyo-e artist Katsushika Hokusai was active from the mid to late Edo period. A late bloomer as an ukiyo-e artist, he rose to preeminence in his late 40s, producing more than 30,000 works up until his death at the age of 90.* His innovative works also had an influence on the wave of Japonisme that spread across Europe in the 19th century, and he is rated highly outside Japan as a leading Japanese artist.

Much mystery surrounds Hokusai, whose life is not well documented, and there are many reports of eccentric behavior, including changing residence 93 times as well as changing his name more than 20 times during his lifetime. The female ukiyo-e artist Katsushika Ōi, also known as Oei, who was active in the closing years of the Edo period, was his daughter.

Hokusai was born in September 1760 in Honjō Warigesui (near present-day Kamezawa, Sumida-ku). His childhood name was Tokitarō, but this was later changed to Tetsuzō. All that is known of his father is that his surname was Kawamura, and at the age of four he was adopted by Nakajima Ise, a mirror craftsman in the service of the Tokugawa shogunate. In his later years, Hokusai himself related how he spent his time drawing from the age of around six, and how, after working at a bookshop and lending library, he became an apprentice to a woodblock carver at the age of around 14, though the details are unclear.

In 1778, at the age of 19, Hokusai entered the studio of Katsukawa Shunshō, a leading exponent of *yakusha-e* (prints depicting kabuki actors), and began training in earnest to become an ukiyo-e artist. The following year he made his debut under the name Katsukawa Shunrō. As a Katsukawa school artist he produced *nishiki-e* (multi-colored woodblock prints) and illustrations for illustrated storybooks.

In 1794, Hokusai left the Katsukawa school and began associating with the Rinpa school, producing sumptuous surimono (privately published woodblock prints often associated with poetry), illustrations for satirical poetry books, and original paintings under the name Tawaraya Sōri. In 1798 he ended his association with the Rinpa school and adopted the name Hokusai Tokimasa. From this point forward he worked as an ukiyo-e artist unaffiliated with any school.

In 1805, he began using the name Katsushika Hokusai, energetically producing book illustrations in collaboration with such leading writers of light literature as Takizawa Bakin and Ryūtei Tanehiko. He exerted his originality and ingenuity in such things as captivating characterization, powerful and meticulous delineation, profound expression using the light and shade of sumi ink, and unconventional composition, and it is even said that books enjoyed huge popularity because Hokusai provided the illustrations. Hokusai provided illustrations for some 200 books, the most important examples of which include *Shinpen suiko gaden* (The Water Margin) and *Chinzei Hachirō Tametomo gaiden: Chinsetsu yumiharizuki* (Unofficial Stories of Chinzei Hachirō Tametomo: Strange Tales of the Master Archer).

From 1810, Hokusai, who had begun using the name Taito, gradually moved away from book illustrations as the focus of his interest and practice shifted to *edehon* (art manuals). *Hokusai manga* (Hokusai's Sketches) (15 volumes), one of the most important art manuals that was produced by Hokusai as a modelbook for his students, contained a total of around 3900 sketches of all manner of things, including people, buildings, everyday articles, landscapes, and weather phenomena.
Also during this period, Hokusai created *nishiki-e* including panoramic aerial views of the Tōkaidō and Edo Bay.

For the 13 years between 1820 and 1833, Hokusai produced *surimono* for such collections as *Genroku kasen kai-awase* (Genroku Poetry Shell Games) (36 prints) and *Umazukushi* (Horses) (30 prints) under the name Iitsu. During this same period, he also energetically produced *nishiki-e*, creating his most important series of works, *Fugaku sanjūrokkei* (Thirty-six Views of Mount Fuji), in his early 70s. He also brought out the landscape series *Shokoku taki meguri* (A Tour of the Waterfalls of the Provinces) and *Shokoku meikyō kiran* (Remarkable Views of Bridges in Various Provinces) as well as many excellent prints of flowers and birds, and *nishiki-e* on such themes as the literary classics and ghost stories.

In 1834, Hokusai changed his name for the last time to Gakyō Rōjin Manji, meaning "Manji, the old man mad about art," with the publication of *Fugaku hyakkei* (One Hundred Views of Mount Fuji), a compilation of prints of Mount Fuji. In a postscript included in the first volume he wrote:

Though I started drawing at the age of six, the pictures I drew until the age of 70 were unworthy of consideration, and it was not until age 73 that I finally understood the physiques of birds, animals, insects and fish and the structures of plants and trees. When I reach 80, I hope to have made even more progress, and at 90 I hope to have mastered the essence of drawing, so that at 100 years I will have achieved a divine state in my art, and after that every dot and every stroke will be as though alive.

As these words show, reflecting on his life as an artist at the age of 75, Hokusai declared that he wanted to continue to improve even after he reached 100 years.
Possessed of an avid desire to create art even as he grew old, Hokusai concentrated on producing original paintings, with the subject matter shifting from manners and customs of the day to events in Japanese and Chinese literature, history based on religion, the classics, and historical events.

In 1849, Hokusai died due to illness at the age of 90. Having passionately pursued his own unique style, it is said that he clenched a paintbrush right up until his last moments and even on his death bed expressed a desire to become a real artist.

*All ages are according to the old Japanese system.

収録作品一覧

冨嶽三十六景（ふがくさんじゅうろっけい）

北斎が70代前半に、江戸や東海道沿いなど様々な場所から富士を描いた揃物。全46図からなり、北斎の名を世界に知らしめた代表作でもある。

《神奈川沖浪裏》
メトロポリタン美術館蔵

《山下白雨》
東京国立博物館蔵

《凱風快晴》
東京国立博物館蔵

《東都浅艸本願寺》
東京国立博物館蔵

《甲州石班澤》
東京国立博物館蔵

《尾州不二見原》
東京国立博物館蔵

《遠江山中》
メトロポリタン美術館蔵

《本所立川》
メトロポリタン美術館蔵

《駿州江尻》
東京国立博物館蔵

《東海道程ヶ谷》
東京国立博物館蔵

《隅田川関屋の里》
東京国立博物館蔵

《御厩川岸より両國橋夕陽見》
東京国立博物館蔵

《深川万年橋下》
東京国立博物館蔵

《下目黒》
東京国立博物館蔵

《東海道金谷ノ不二》
東京国立博物館蔵

《五百らかん寺さゞゐどう》
東京国立博物館蔵

富嶽百景
ふがくひゃっけい

「冨嶽三十六景」に続いて出版された富士が題材の単色刷りの作品。全102図、全三編で構成されている。

《千金富士》
東京国立博物館蔵

《海上の不二》
東京国立博物館蔵

《登龍の不二》
東京国立博物館蔵

《孝霊五年不二峰出現》
東京国立博物館蔵

《遠江山中の不二》
東京国立博物館蔵

《霧中の不二》
東京国立博物館蔵

《三白の不二》
東京国立博物館蔵

《七夕の不二》
東京国立博物館蔵

《蘆中筏の不二》
東京国立博物館蔵

《雪の旦の不二》
東京国立博物館蔵

《竹林の不二》
東京国立博物館蔵

《江戸の不二》
東京国立博物館蔵

《快晴の不二》
東京国立博物館蔵

《田面の不二》
東京国立博物館蔵

《鏡臺の不二》
東京国立博物館蔵

《烟中の不二》
東京国立博物館蔵

北斎漫画
ほくさいまんが

人物や動物、植物、妖怪などありとあらゆるものが描かれた絵手本。1814〜1878年に刊行された全十五編からなる、北斎の代表作のひとつ。

個人蔵

北斎漫画一編　　　　北斎漫画二編　　　　　　北斎漫画二編　　　　　北斎漫画二編

北斎漫画二編　　　北斎漫画二編　　　　北斎漫画二編　　　　北斎漫画三編　　　北斎漫画三編

北斎漫画三編　　　　北斎漫画三編　　　　　北斎漫画四編　　　　　北斎漫画六編

北斎漫画六編　　　　北斎漫画六編　　　　北斎漫画八編　　　　北斎漫画八編

北斎漫画九編　　　　北斎漫画九編　　　　北斎漫画十編

りゃくがはやおしえ
略画早指南

島根県立美術館（永田コレクション）蔵

己痴羣夢多字画尽
おのがばかむらむだじえづくし

島根県立美術館（永田コレクション）蔵

花鳥

東京国立博物館蔵

《黄鳥　長春》　《鵙　白粉花》　《鶸 翠雀 蛇苺 虎耳草》　《芍薬 カナアリ》　《子規 杜鵑花》　《文鳥 辛夷花》　《鶺鴒 藤》

《菊に雀》
メトロポリタン美術館蔵

諸国瀧廻り

各地の名瀑を題材とした、8枚揃いの連作。ベロ藍と呼ばれる青色顔料を使い、深く美しい水を表現している。

《木曽路ノ奥阿彌陀ヶ瀧》
メトロポリタン美術館蔵

《下野黒髪山きりふりの滝》
メトロポリタン美術館蔵

《和州吉野義経馬洗滝》
メトロポリタン美術館蔵

《東都葵ヶ岡の滝》
メトロポリタン美術館蔵

《美濃ノ国養老の滝》
メトロポリタン美術館蔵

《木曽海道小野ノ瀑布》
メトロポリタン美術館蔵

《東海道坂ノ下清瀧くわんおん》
メトロポリタン美術館蔵

《相州大山ろうべんの瀧》
メトロポリタン美術館蔵

諸國名橋奇覧

全国の珍しい橋を描いたシリーズ。「冨嶽三十六景」と同じ版元の西村屋与八から刊行された全11図からなる揃物。

《三河の八ツ橋の古図》
メトロポリタン美術館蔵

《東海道岡崎矢はぎのはし》
メトロポリタン美術館蔵

《かうつけ佐野ふなはしの古づ》
メトロポリタン美術館蔵

《摂州 天満橋》
メトロポリタン美術館蔵

《ゑちぜんふくゐの橋》
メトロポリタン美術館蔵

《かめゐど天神たいこばし》
メトロポリタン美術館蔵

《飛越の堺つりはし》
メトロポリタン美術館蔵

《足利行道山くものかけはし》
メトロポリタン美術館蔵

百物語(ひゃくものがたり)

「百物語」とは、江戸時代に流行した怪談会のこと。怖いモチーフの中にも、どこかユーモラスな表情を見せるのが北斎流のお化け。

《百物語・こはだ小平二》
シカゴ美術館蔵

《百物語・お岩さん》
シカゴ美術館蔵

《百物語・笑ひはんにや》
東京国立博物館蔵

《百物語・さらやしき》
東京国立博物館蔵

100 WRITING
& CRAFTING PAPERS
100枚レターブック

HOW TO USE
使い方

100枚レターブックは、切り離して、いろんなシーンで楽しめます。お気に入りの額に入れて飾ると、素敵なインテリアに。便箋としてそのまま使うのはもちろん、表面の美しい絵を生かして、折り曲げて使うのもお勧めです。小さなプレゼントであれば、包装紙として使うこともできます。アイデア次第で、たくさんの用途が楽しめます。100枚レターブックの楽しみ方は、特設サイトでもご覧いただけます。

INTERIORS
飾る

LETTER
書く

WRAP
包む

HOW TO MAKE A POCHIBUKURO
ぽち袋のつくり方

レターブックを、
型紙に合わせて切りとります

片側を折り曲げます

もう一方を折り曲げ、
重なる部分をのりで貼ります

下部分を折り曲げ、
重なる部分をのりで貼り完成です

小さなプレゼントを入れるのに便利なぽち袋。
本書掲載の型紙を使えば、
サイズ違いのぽち袋が簡単につくれます。

長方形(大) Rectangular envelope (large)

長方形(小) Rectangular envelope (small)

のりしろ ▲ Glue tab ▲
のりしろ ○ Glue tab ○
のりしろ ■ Glue tab ■

② D
② D
④ B
④ B
③ A
① C

MAKING ENVELOPES
型紙の使い方

Use the papers provided in this book to make envelopes large, small and mini. In order to be able to use the templates over and over again, we recommend copying them onto sheets of heavy paper.

Directions
1. Cut out the template along the solid lines.
2. Lay the template on the outside of the paper of your choice. Trace the outline of the template in pencil or pen onto the paper. Cut along the lines with a cutting knife and remove the envelope to be.
3. For stationery envelopes: Fold tabs 1–4 (in that order) back in "mountain folds" and apply glue to the back side of the glue tabs marked ○. For mini money envelopes: Fold tabs A–D (in that order) back in "mountain folds" and apply glue to the glue tabs marked ▲ and ▪ (in that order).

型紙をコピーして実線で切り取る。
使いたい紙の表面に型紙をのせ、
えんぴつなどで型を取り、カッターで切り取る。

封筒：①〜④の順に山折りし、
のりしろ○の裏面をのりづけする。

ぽち袋：A〜Dの順に山折りし、
のりしろ▲、のりしろ■の
順に裏面をのりづけする。

実物大
Actual size

正方形（大） Square envelope (large)

正方形（小） Square envelope (small)

D
B A
C

のりしろ ▲ Glue tab ▲
のりしろ ○ Glue tab ○
のりしろ ■ Glue tab ■

HOKUSAI
100 WRITING & CRAFTING PAPERS
北斎100枚レターブック

2025年1月11日 初版第1刷発行

編著	パイ インターナショナル
デザイン	株式会社DK　後藤寿方
執筆	進藤つばら
翻訳	パメラミキ
撮影	藤牧徹也
編集	高橋かおる

発行人　三芳寛要

発行元　株式会社パイ インターナショナル
〒170-0005　東京都豊島区南大塚2-32-4
TEL 03-3944-3981　FAX 03-5395-4830
sales@pie.co.jp

PIE International Inc.
2-32-4 Minami-Otsuka, Toshima-ku, Tokyo 170-0005 JAPAN
TEL +81-3-3944-3981　FAX +81-3-5395-4830
sales@pie.co.jp

印刷・製本　TOPPANクロレ株式会社

© 2025 PIE International
ISBN978-4-7562-5972-1 C0070
Printed in Japan

本書の収録内容の無断転載・複写・複製等を禁じます。
ご注文、乱丁・落丁本の交換等に関するお問い合わせは、小社までご連絡ください。
著作物の利用に関するお問い合わせはこちらをご覧ください。
https://pie.co.jp/contact/

・ページをしっかり開き、ゆっくり引っ張るとよりきれいにはがれます。
・筆記用具によっては、インクがにじむことがあります。
・「100枚レターブック」特設サイトでレターブックの取扱店舗一覧、使い方を紹介した連載などをご覧いただけます。最新情報をお届けするメルマガもぜひご登録ください。
著作物の利用に関するお問い合わせはこちらをご覧ください。
https://pie.co.jp/contact/

「100枚レターブック」は株式会社パイインターナショナルの登録商標です。
［登録商標第5921106号］

HOKUSAI 100 WRITING AND CRAFTING PAPERS

©2025 PIE International
All rights reserved. No part of this publication may be reproduced, stored in a retrieval system,
or transmitted in any form or by any means, graphic, electronic or mechanical, including photocopying
and recording, or otherwise, without prior permission in writing from the publisher.

PIE International Inc.
2-32-4 Minami-Otsuka, Toshima-ku, Tokyo
170-0005 JAPAN
international@pie.co.jp
www.pie.co.jp/english

ISBN978-4-7562-5979-0 (Outside Japan)
Printed in Japan

冨嶽三十六景
東都浅艸
本願寺

葛飾北斎筆

冨嶽三十六景 東海道 程ヶ谷

冨嶽三十六景 隅田川関屋の里

冨嶽三十六景 東海道金谷ノ不二

千金富士

海上の不二

登龍の不二

孝靈五年
不二峯出現

霧中の不二

竹林の不二

田面の不二

鏡臺不二

群鳥

震災瀑番

炎烟硝

เด็กหนู
ตะกละ

โครงสร้างเป็น
ทรง
ก้อนกลม ๆ

ตุ๊ด ๆ
ป้อม ๆ

그림가온대에 잇는것은무엇이오

さるハてもふゑんかくせ
ほこんさろちヘー
そのぬうみて
み
する
あーなひろうを
とうとんぐ
うし

うう
うう
うう
うう

とう
とう
とう
うあり

むま

うし

うごきやかすゞめのあそに足た

お名前／御社名をご記入
下さいますようお願いします。

はがき

ねん　くみ　なまえ

四	と	ん	で	ひ	に	入	る	夏	の	虫
五	を	ど	り	字	を	わ	す	れ	け	り

かきぞめやこころに
もあらぬくづし字に

諸国瀧廻り 東都葵ヶ岡の滝

諸國瀧廻リ
東海道坂ノ下清瀧くわんをん

諸國瀧廻リ　相州大山ろうべんの瀧

諸國名橋奇覧 三河の八橋の古圖

諸國名橋奇覽 攝州 天滿橋

前北齋為一筆

諸國名橋奇覽
攝州天滿橋
前北齋為一筆

諸國名橋奇覽
ゑちぜん
ふくゐの橋

前北齋一筆

諸國名橋奇覧 ゑちぜん ふくゐの橋

北斎改為一筆

諸國名橋奇覧 足利行道山